Artists in Snowdonia

Artists in Snowdonia

JAMES BOGLE

Argraffiad cyntaf: Hydref 1990
First impression: October 1990
Ailargraffiad: Hydref 1993
Second impression: October 1993

ⓗ Y llyfr a'r testun: Y Lolfa Cyf., 1990
ⓒ *The book and text: Y Lolfa Cyf., 1990*

Perthyn hawlfraint y lluniau i'r orielau a nodwyd
The copyright of the pictures belongs to the galleries noted

Rhif Llyfr Safonol Rhyngwladol: 0 86243 222 7
ISBN: 0 86243 222 7

Argraffwyd a chyhoeddwyd yng Nghymru gan
Printed and published in Wales by
Y Lolfa Cyf., Talybont, Ceredigion SY24 5HE;
ffôn/*phone* (0970) 832304, ffacs/*fax* 832782.

For Elizabeth, Dan, Katharine and Thomas

ACKNOWLEDGEMENTS

I am grateful to the galleries, museums and owners acknowledged for permission to reproduce the works illustrated, and in addition to the Courtauld Institute of Art for permission to reproduce Walter Crane *Llyn Elsie* and Augustus John *Llyn Treweryn;* also to John Piper, Kenneth Rowntree and Kyffin Williams for their kind permission to reproduce their works.

JAMES BOGLE

FOREWORD

Artists in Snowdonia consists of an introduction and 30 reproductions of landscapes painted by various artists, all of which lie within the National Park or very near it. They seek to show how artists have responded to the scenery of Snowdonia over more than 200 years. For interest, the place of painting is included in a note; a comparison of the painting with the scene today can be revealing and several of the viewpoints are especially attractive.

INTRODUCTION

The Paradox

SNOWDONIA is popular. It has been estimated that some 400,000 people make the ascent to the summit of Snowdon each year, whether by foot or by train. Snowdon is Britain's most visited mountain. There is a visitor rate to the Snowdonia National Park of 9 million visitor days per year. People come to Snowdonia in very large numbers with the intention of enjoying the beauty of a district which includes the highest mountains in England and Wales.

The contrast with 250 years ago could hardly be greater, for then Snowdonia was very isolated. Not only were there hardly any visitors other than those who came of necessity; those who did make the journey found what they saw distasteful and disturbing, by no means enjoyable or beautiful. Daniel Defoe in his *Tour* of Britain thought the Welsh mountains *horrid, frightful* and *barbarous;* Snowdon *a monstrous height;* the Welsh mountains outdid the Alps *in the terror of their aspect* and *in difficulty of access to them.* One English visitor described the environs of Snowdon as *the Fag End of Creation; the very rubbish of Noah's Flood.* He was using conventional language from the previous century, but his description clearly expressed his dislike of the area. Even in 1768, when others had begun to take a different point of view, Sir Harbottle

Grimston could only describe Snowdonia as *dreary*. In part such distaste can be put down to the sheer difficulties of travelling, to bad roads, to poor or even non-existent accommodation and to the dangers a visitor might meet; but beyond that the mountains themselves were felt to be oppressive, threatening and ugly. How then did the change come about so that the mountains no longer aroused horror and dislike, but widespread admiration? A variety of writers and travellers played their part and notable among them were the artists.

Precursors

Hywel ap Owain, Prince of Gwynedd, sang in appreciation of his beloved Meirionnydd as far back as the twelfth century. It shows that from an early date the mountains of Snowdonia could be loved by those who lived there. The bards who followed him dwelt on the strength and majesty of the mountains in their mantle of ice and snow. But the mountains could also seem unwelcoming even to those who lived among them. One later Welsh poet, living in the wilds of the mountains among the grey rocks, with only seagulls for company, longed for the gentle lushness of the forest and for the habitations of his fellow men.

The seventeenth century saw travellers come to Wales and climb the mountains, especially Snowdon—such men as Thomas Johnson, John Ray, Edward Lhuyd and Edmund Halley. Their chief interests were scientific and botanical and there is little to show that they enjoyed the mountain scenery as such;

although Lhuyd, who had a considerable knowledge of the area, perhaps rather daringly made out a case for the attractiveness of the variety of the scenery in Meirionnydd, including the high mountains.

An English visitor to Wales in the first half of the 18th century who did appreciate what he saw was Thomas Herring, Bishop of Bangor from 1738 to 1743. Visitor he was, in spite of being bishop of the diocese which included Snowdonia, for he was also Dean of Rochester and he no doubt found that deanery a good deal more convenient and comfortable than the bishop's residence in Bangor. In 1738 he wrote to a friend after what he described as the most agreeable journey he had ever had in his life—his first visit to North Wales. He found Wales *a country altogether as entertaining as it was new. The face of it is grand and bespeaks the magnificence of nature.* Level ground and the little artificialities of landscape gardening would seem contemptible *after I had been agreeably terrified with something like the rubbish of creation.* Although he used conventional unflattering language, *the rubbish of creation,* and was terrified, it was an agreeable terror that he felt when he was confronted with mountain scenery. *The things which entertained me were the vast ocean, and ranges of rocks, whose foundations are hid, and whose tops reach the clouds.* Herring went on to describe an evening's outing, the memory of which he especially treasured, along the shore, into a village with a church and houses at the entrance to a deep valley, up which his party proceeded *till our prospect was closed, though much illuminated, by a prodigious cataract from a mountain, that did as it were, shut the valley.* It seems likely that Herring was describing an excursion from Bangor across the Traeth Lafan to the village of Aber and on to the Aber Falls (Rhaeadr Fawr). Herring commented, *All these*

images together put me much in mind of Poussin's drawing... Indeed both the journey and the country, and the residence were most pleasing to me. Herring did not seem to have considered venturing up a mountain, but he certainly was beginning to appreciate Welsh mountain scenery. His contrast between that and *the little niceties of art* in landscape gardening, which loomed so very large in 18th century taste, is particularly illuminating; so is his comparison of the landscape to the works of Poussin.

It does not seem that Herring's interest was taken up; his letter describing his journey was not published until 1777, twenty years after his death. 1741 saw the first recorded ascent of Snowdon *for fun*. This was by a party led by William Morris, one of the brothers from Anglesey famous for their concern for Welsh antiquities and culture. The party had bad weather, so no comment was made on the view. The 1740's saw topographical draughtsmen beginning to penetrate the mountainous regions in North Wales to depict well known castles. Samuel and Nathaniel Buck were pioneers and they published a view of Dolbadarn Castle in 1742; they claimed to have made their drawings on the spot. But they had no interest at all in the mountain scenery; their concern was purely with the buildings, and the mountains they drew were stilted. John Boydell was also active in the 1740's publishing engravings made from his own drawings, including those made in Wales, and they were extremely popular. But neither was he interested in the mountains. However these artists did pave the way for later ones who were.

In 1752 Sir George (later Lord) Lyttleton made the first of his journeys to Wales. Lyttleton was a man of culture, a politician, a writer, a poet and a keen landscape gardener. He lived at Hagley Hall, near Birmingham, where the

Welsh mountains formed a background to his grounds. There is no record of his impression of this, his first visit to Wales, but it was to be one of several.

In 1755 Lyttleton wrote two descriptive letters to a friend about his second journey to Wales, this time to the North. Not unnaturally he had an interest in the homes and estates of the gentry, but he also took an interest in the natural landscape. Indeed he seems to have gone further than most in making the full ascent of mountains. When Lyttleton reached the Berwyns and made the ascent, he was filled with *awful astonishment. Nature in all her majesty is there; but it is the majesty of a tyrant, frowning over the ruins and desolation of a country. The enormous mountains, or rather rocks, of Merionethshire inclosed us all around. There is not upon these mountains a tree or shrub, or a blade of grass; nor did we see any marks of habitations or culture in the whole space. Between them is a solitude fit for Despair to inhabit whereas all we had seen before in Wales seemed formed to inspire the meditations of Love.* Lyttleton here fell back on the older language in which the mountains were the ruins and desolation of creation; there is no appreciation of them. It was different however when he came to Snowdonia.

At first the mountains here seemed forbidding too. He commented on the view from Traeth Mawr, *The view of the sands is terrible, as they are hemmed in on each side with very high hills, but broken into a thousand irregular shapes. At one end is the ocean, at the other the formidable mountains of Snowdon, black and naked rocks, which seem to be piled one above the other. The summits of some of them are covered with clouds and cannot be ascended. They do altogether strongly excite the idea of Burnet, of their being the fragment of a demolished world.* But then the next day the weather changed and the sun

shone. *The grandeur of the ocean, corresponding with that of the mountain, formed a majestic and solemn scene; ideas of immensity swelled and exalted our minds at the sight; all lesser objects appeared mean and trifling so that we could hardly do justice to the ruins of an old castle.*

There followed the account of the ascent of a mountain. *This morning (July 7th) being fair, we ventured to climb up to the top of a mountain, not indeed so high as Snowdon, which is here called Moel Guidon, i.e. the nest of the Eagle; but one degree lower than that called Moel Happock, the nest of the hawk; from whence we saw a phenomenon, new to our eyes, but common in Wales.* While Snowdonia is called Eryri, nest of the Eagle, Moel Guidon is not otherwise known. Moel Happock is obviously Moel Hebog, mountain of the hawk, easily reached from Bryncir, where Lyttleton was staying. *On the one side was midnight, on the other bright day; the whole extent of the mountain of Snowdon, on our left hand, was wrapped in clouds, from top to bottom; but on the right, the sun shone most gloriously over the sea coast of Caernarvon. The hill we stood upon was perfectly clear, the way we came up a pretty easy ascent; but before us was a precipice of many hundred yards, and below a vale which though not cultivated has much savage beauty; the sides were steep, and fringed with low wood. There were two little lakes or rather large pools, that stood in the bottom, from which issued a rivulet, that serpentines in view for two or three miles, and was a pleasing relief to the eyes.* Lyttleton is likely to have been looking down on Llyn Gwynant and Llyn Dinas and the valley of the Afon Glaslyn. *But the mountain of Snowdon, covered with darkness and thick clouds, called to my memory the fall of Mount Sinai, with the laws delivered from it, and filled my mind with religious awe.* Lyttleton's account has been quoted extensively for it

stands among the earliest records of an ascent of a mountain in Snowdonia for pleasure and interest—his journey was undertaken *so that I may, by this ramble, preserve a stock of health that may last all winter and carry me through my parliamentary campaign.* It also, at least in part, takes a fresh attitude towards mountain scenery.

At the same time as the beginning of mountain travel in Wales, there was a revival of interest in Welsh culture, in the Welsh language and literature, in antiquities and generally in matters Welsh. Pioneers in this work were Lewis Morris and his brothers from Anglesey, already mentioned. The movement spread to Welshmen living in London, and there in 1751 the Honourable Society of Cymmrodorion was founded for the preservation of Welsh language, poetry and customs, led by a number of wealthy and distinguished Welshmen. The Celtic revival was quite widely noticed in English literary circles, most notably by Thomas Gray, the poet, who wrote 'The Bard' in 1757. Its theme is the legend that Edward I, the conqueror of Wales, slaughtered all the bards as he advanced until but one was left, standing upon the slopes of Snowdon, watching the troops approach. He uttered a great curse on the king and his line before casting himself off a rock into the foaming water below. There is no indication that Gray had ever visited North Wales, but his poem, which was widely read, helped to arouse interest in the area, not least among several artists who illustrated it.

In 1758 or 1759 (or perhaps both years) Robert Price made a tour of North and Mid Wales. Price came from a Welsh landowning family and had travelled to Rome and studied landscape there. He made his Welsh tour with a botanist, Benjamin Stillingfleet. On it Price made a number of pencil

drawings. He had a particular interest in waterfalls and drew several of the better known ones. He also made some mountain drawings at Llanberis. These drawings were sensitive and careful and his response was a vast improvement on that of the early topographical draughtsmen, even if his work seems rather to lack confidence. A bolder treatment of the North Wales landscape was to follow in a few years.

The First Artists in Snowdonia
(1760-1800)

Among the first to illustrate 'The Bard' was Paul Sandby. His picture was exhibited in 1761. It is now lost, but when it was shown it created quite a sensation. *Sandby has made such a picture! such a bard! such a headlong flood! such a Snowdon! such giant oaks, such desert caves! If it is not the best picture that has been painted in this century in any country I'll give up all my taste to the bench of Bishops.* The remarks point to a picture in the dramatic and sublime mood. Whether Sandby actually travelled to Wales before painting his picture is unknown; it is quite likely that he did not feel the need to do so. That omission was however to be made good later.

About the year 1765 or 1766 Richard Wilson produced a series of six paintings of Welsh scenery, which he intended to have published as prints. Wilson was born in 1713 in Penegoes, near Machynlleth, where his father was Rector. He went to London in 1729 to study painting and in his earlier years as a painter he was as inclined to paint portraits as landscapes. In his later thirties he

travelled to Italy and was there advised to change from portrait painting to landscape, which he did with considerable success. In Rome he was deeply influenced by the ideal landscape style of Claude Lorraine and Gaspard Dughet and painted many works of the Roman countryside in this manner. He returned to England about 1756. In 1744/5, before he went to Italy, Wilson had painted Caernarfon Castle. After his return in the early 1760's Wilson twice painted Dolbadarn Castle. It must be said that these landscapes bear very little relationship to the actual scene other than inlcuding a round tower, a lake and a mountain; they are deeply indebted to classical models. The scenes of the 1765/6 series were 'Caernarvon Castle', 'Snowdon from Llyn Nantlle', 'Cader Idris', 'Llyn y Cau', 'Pembroke Town and Castle', 'Kilgaran', and the 'Great Bridge over the Taaffe, South Wales'. This series, though not free from classicising influence, is much closer to nature. Included are two striking paintings of mountains themselves, 'Snowdon' and 'Llyn y Cau, Cader Idris'. The prints were eventually published in 1775. By that time several of the views had been exhibited as paintings and were widely noticed. Wilson's achievement in painting Welsh mountain scenery was pioneering. With him the paintings of Welsh mountain landscape became aesthetically and intellectually acceptable. At first this was due to Wilson's use of classical Roman models. Besides this Wilson drew on historical and political associations for his Welsh pictures. And then in time the excellence of Wilson's work commended itself for its own sake.

At much the same time as Wilson was at work in Wales George Barret also travelled there. Barret was born in Dublin and brought up in that city. He was largely self-taught as an artist and began landscape painting in Ireland. In

1763 he came to London and soon after that began exhibiting there. His Irish landscape work prepared him for the wild country of North Wales, in which he came to specialise. He had painted a view of Snowdon by 1765, and he exhibited Welsh pictures over a number of years. Llanberis Lake was a favourite subject.

Paul Sandby's first recorded tour of North Wales was made in 1771, in company with the influential landowner Sir Watkin Williams-Wynn. Sir Watkin was a member of the Cymmrodorion and had also bought pictures from Richard Wilson. His interest in the scenery of North Wales had been aroused (he himself was an amateur artist) and he took a highly competent draughtsman with him to record it. Sandby's company two years later in 1773 was Joseph Banks, Dr. Solander and Mr. Lightfoot. Their interests were scientific and botanical but that did not prevent them giving free rein to Sandby for his drawing. From Llanberis the party ascended Snowdon; Glyder Fawr(?); Llyn y Cŵn; Llyn Bochlwyd; Tryfan(?); Clogwyn Du'r Arddu; Dolbadarn Castle and Carnedd Llywelyn—a remarkable mountaineering achievement for its time. Sandby's expeditions were issued in four series of aquatints. His first consisting of twelve views of South Wales was produced in 1775 and dedicated to 'the Honourable Charles Greville and Joseph Banks Esquire'. Another series of twelve views of North Wales was produced in 1776, dedicated to Sir Watkin Williams-Wynn. Among other views it included 'Harlech Castle with Snowdon in the distance', 'Caernarvon Castle', 'Llanberis Lake', 'Castle Dolbadarn and the great mountain Snowdon', 'Conway in the County of Caernarvon' and 'Pont y Pair over the River Conway'. In the following year Sandby published a third series of views in North and South Wales which included a view of the

Traeth Mawr, Pont Aberglaslyn, a distant view of Cadair Idris from near Bala, Bala Lake and the Swallow Falls near Llanrwst. A fourth series was published in 1786; of North Wales it included two views of Caernarfon Castle, one of Llanrwst and one of Conwy. Sandby was an innovator in reproductive technique, using aquatint to reproduce his watercolours. This it did very effectively, accurately showing the tonal values of the original. His prints, new both in technique and subject matter, must have attracted considerable attention.

1777 was an exceptionally fruitful year for artistic travellers to Snowdonia. One such was Francis Towne from Exeter who was a watercolour painter of distinction and sensibility. Towne travelled throughout Wales and drew Machynlleth, Cadair Idris, Bala Lake, Pont Aberglaslyn and Llyn Cwellyn among other views in the North. Towne had a distinctive style in drawing mountains, which he first developed on this trip to Wales. He could lay bare the structure of the cliffs and hills he was presenting clearly. It has been said that if he had lived in the era of rock climbers' guide books he would have been much in demand for his skill in drawing the mountain face. He was to continue to develop his style in the Alps, where his best known drawings were made, and also in the Lake District. Another artist who rejoiced in Welsh scenery was Samuel Hieronymus Grimm. Grimm was born and brought up in Switzerland, moved to France in his early thirties and then after two or three years moved on to England. He readily found patrons in England and in 1777 was employed by Henry Penruddocke Wyndham to accompany him on a tour of Wales with the intention of providing illustrations to a second edition of Wyndham's book *A Gentleman's Tour through Monmouthshire and Wales*. Wyndham saw to it that they made a very comprehensive tour and Grimm

made a large number of drawings to record it. He had a very neat and precise manner of drawing. He was especially fond of waterfalls and must have persuaded Wyndham to make several diversions to see fine sights of this kind.

There were two further artists active in or about 1777—Moses Griffith and John Ingleby. They were employed by Thomas Pennant, the author of *A Tour in Wales* and *The Journey to Snowdon*. Griffith was a self taught artist. At times his style is naive, but he generally rises above that. He made a considerable number of drawings which were engraved for Pennant's three volumes, and those in Snowdonia include a fine view of the Summit of Snowdon from Capel Curig, a view of Nantperis (with Dolbadarn Castle) and a view of Dinas Emrys. In addition Pennant had a special edition of his volumes prepared with very wide margins, in which Griffith and Ingleby coloured the engravings and also provided a multitude of further small watercolours, a notable achievement. It is obvious that Griffith followed Pennant to the summit of the mountains as there is a very accurate drawing of the cantilever on the summit of Glyder Fach and also a drawing of Tryfan from the same spot. Like Grimm, Griffith and Ingleby played their part as book illustrators in making Snowdonia better known.

Another artist born and brought up on the continent who came to work in Britain was Philippe Jacques de Loutherbourg. He was born in Strasbourg and became a member of the French Academy before travelling to England. De Loutherbourg was a capable artist and was commissioned to design sets for Drury Lane. He had a liking for the dramatic and his drawings reflect the romantic sublime.

A third artist born and brought up on the continent visited North Wales in

1789. This was John Baptiste Malchair. He came from Cologne and moved to England at the age of 23. He taught both drawing and music in Oxford: there are a number of drawings of the city. Wales called out a rather grander style; his 1789 tour included a drawing 'Between Aberglaslyn and Beddgelert'. Malchair returned to Wales in 1791 and 1795.

John Warwick Smith was a great topographical artist. He visited Wales every year from 1784-1798. He was in North Wales in 1790 and again in 1792, the latter year in company with Julius Caesar Ibbetson and the Honourable Robert Fulke Greville, an equerry at court. During this trip they were caught in a thunderstorm at the Pass of Aberglaslyn; both Smith and Ibbetson recorded the scene—Smith in watercolour and Ibbetson in oils. Ibbetson had a greater interest in people than Smith and was less of a landscape painter. Between them they did much to record the life and scenery of Wales in their day. John Webber's reputation as a topographical artist earned him employment with Captain Cook on his last voyage of discovery in the Pacific. He made a tour of Wales in 1790 and again in 1791 accompanied by a geologist, William Day. Webber drew several attractive views in North Wales and exhibited four Welsh scenes at the Royal Academy in 1792. Nicholas Pocock was chiefly a marine artist, but he was capable of drawing some very pleasing mountain landscapes. He visited North Wales in 1795.

The renowned caricaturist, Thomas Rowlandson, made a tour of North and South Wales in 1797, together with his friend and pupil, Henry Wigstead. Rowlandson's landscapes are apt to be too mannered to be entirely convincing, skilled draughtsman though he was. There is one entertaining drawing of 'An Artist Travelling in Wales' (does it portray Wigstead?) showing the artist

on horseback carrying all his sketching gear, drenched by a downpour, surrounded by unwelcoming hills. Rowlandson and Wigstead together provided illustrations for the book which Wigstead wrote.

In his short life Thomas Girtin acquired the reputation of being an outstanding artist. Like his contemporary Turner he was still developing as an artist when he visited Wales in 1798 (he was only 23 years old). He drew a wide variety of subjects in Snowdonia, including rivers, waterfalls and mountains, and his technique showed on the one hand a new freedom, and on the other a new responsiveness to what he saw. Girtin is probably best known for his moorland scenes—bleak expanses of bare land and sky; but it is obvious from his Welsh pictures that he had a real feeling for the mountains there. Besides his 1798 tour Girtin probably visited North Wales in 1800.

The two tours which J.M.W.Turner made in 1798 and 1799 were of first importance, both for his own development as an artist, and in the appreciation of Welsh mountain scenery. In the mountains Turner was driven to experiment with his technique in ways which were very effective. Such is mountain weather that an artist is driven, if he can, to express the atmosphere of the scene he is drawing. Turner responded to that challenge and it remained a dominating motif throughout his career. On his tour Turner acknowledged a debt to Richard Wilson by calling at his birth place in Penegoes; he continued his indebtedness by painting some of his pictures in the classic style of Wilson, and before him Claude Lorraine, while he was in Wales. Like Wilson he had a strong sense of the importance of the historical and a number of his Welsh pictures are endued with historical associations. There is, for instance, a mountain scene with Edward I's army on the march, recalling Thomas

Gray's 'The Bard'. The most original of Turner's Welsh drawings was a series made in 1799 of purely mountain scenes. Unusually quite large drawings were made on the spot, and some colour may even have been applied (generally Turner worked in sketch books and drew finished works from them in his studio). Turner's response to the mountains in these drawings is very direct and full of empathy. A central aesthetic concept for the late eighteenth and early nineteenth century was the sublime, that which exalts, but at the same time engenders awe or fear. Turner vigorously and successfully strove to convey the sublimity of the mountains in his Welsh work.

By 1800 Wales was fast becoming a Mecca for British artists and the artistic value of its scenery was assured.

After 1800

By 1800 Girtin and Turner had drawn inspiration from North Wales; Cotman and Cox were soon to do so. These were artists of the first rank and there were numerous others too who played their part in letting the mountains of North Wales become well known. After their work there was no question but that the mountains were to be enjoyed and admired. Gone for ever was the *rubbish of creation* and its *dreariness*. The way was paved for George Borrow's judgement in *Wild Wales* (1862)—*Perhaps in the whole world there is no region more picturesquely beautiful than Snowdon, a region of mountains, lakes, cataracts and groves, in which Nature shows herself in her most grand and beautiful forms.*

Richard Wilson—*'Snowdon from Llyn Nantlle'* c.1765—National Museums and Galleries on Merseyside (Walker Art Gallery, Liverpool)

It is a happy circumstance that when the most gifted of painters born in Wales chose its highest and most famous mountain as his subject he produced a masterpiece. This picture is one of a series painted some years after Wilson's return from Rome when he made a tour of Wales. In it Wilson has kept some features of Italian landscape—the warmth of the sunlight, more typical of Rome than of North Wales; the prominent trees framing the scene with sinuous trunks and carefully rendered foliage; and the group of figures enlivening the foreground and humanising the scene as a whole. Much of this was probably invented or imported into the picture and the shape of the lower part of Y Garn, the mountain on the right of the picture, has been accentuated to make it more dramatic. For those with an eye for detail, the second lake in the picture is not an invention. Wilson's viewpoint was further down the valley than the present day one and there was a further, slightly lower lake now filled in as a result of slate quarrying. Wilson's Snowdon is not overpowering or threatening, but faithful to the 18th century manner, an object of peaceful and orderly contemplation.

This very fine, but not best known, view of Snowdon can be enjoyed from the bridge over the river Llyfni on the B4418 road from Penygroes to Rhyd Ddu. (MR 509530)

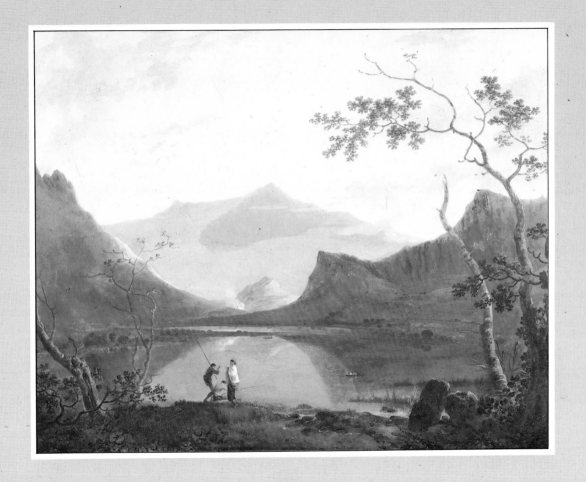

Richard Wilson—_'Llyn-y-Cau, Cader Idris'_ c.1765—Tate Gallery, London

When Wilson undertook to paint Cadair Idris, the best known mountain of Meirion-nydd, he did not choose to portray the summit, but instead the striking Llyn Cau, on its southerly side, dominated by the subsidiary summit of Craig Cau. The true summit, Pen y Gadair, is only suggested at the extreme right of the picture. The resulting painting is a strange and powerful one. Wilson's viewpoint, which it is unlikely anyone had chosen before, took him high up into the wilder and more rugged parts of the mountain. The dark blue waters of the lake with the background of the sheer cliffs of Craig Cau (of which the height is exaggerated considerably) make a dramatic scene. If his painting of Snowdon went a long way from the kind of landscape he had learned to paint in Italy, this painting of Cadair Idris goes further, and the only aspect of it that obviously comes from the south is the warm glow as of Italian sunshine. For all that the scene is an orderly one. The whole of the foreground is invented. The great boulders together with the long line of the horizon give stability. Wilson has striven to show that human beings can be at home in such an environment—enjoying the view through a telescope, painting it (a significant touch), grazing cattle (a good deal higher than would be possible in actuality) and even contemplating the scenery from the brink of the crater's edge.

Wilson appears to have painted this view from the flank of Mynydd Moel (MR 727136) on the summit ridge of Cadair Idris. Llyn Cau can be reached by taking the well defined path from Minffordd which starts at the car park close by the junction of the B4405 with the A487.

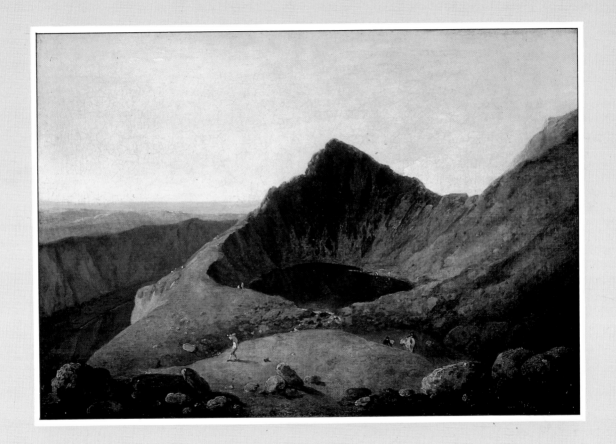

Francis Towne—*'Bridge and Waterfall near Llyn Cwellyn'* c.1777—Laing Art Gallery, Newcastle upon Tyne, Tyne and Wear Museums Service

Towne's first serious work as an artist was carried out in Devonshire. He first made a journey to mountainous country in 1777 when he toured Wales. The result of his tour was a series of drawings, located by the artist, several of which are also dated, executed in the months of June and July 1777. There is a stripping away of all obtrusive detail and a concentration on outline and simple bold masses. Like other eighteenth century artists Town was quite capable of altering nature if it suited his pictorial purpose; nevertheless his scenes remain quite recognisable. Towne's Welsh tour initiated a particular interest in mountains. He had a notable feeling for their structure which he illustrated with care.

This drawing of the 'Bridge and Waterfall near Llyn Cwellyn' illustrates the development in style which Towne's Welsh tour brought about. Mynydd Mawr is given a clear outline in the background and the structure of its cliffs is carefully drawn. The waterfall in spate in the centre foreground has obviously attracted the artist. There are fewer trees in the drawing than there are around the falls now, but that may not have been unfaithful to nature. The little cottage between the road and the stream is more likely to have been an invention.

The bridge and waterfall drawn by Towne lie beside the A4085 from Beddgelert to Caernarfon in the little village of Betws Garmon to the north west of Llyn Cwellyn. The artist's viewpoint was opposite Hafodty, 100 yards downstream from the falls. (MR 547564)

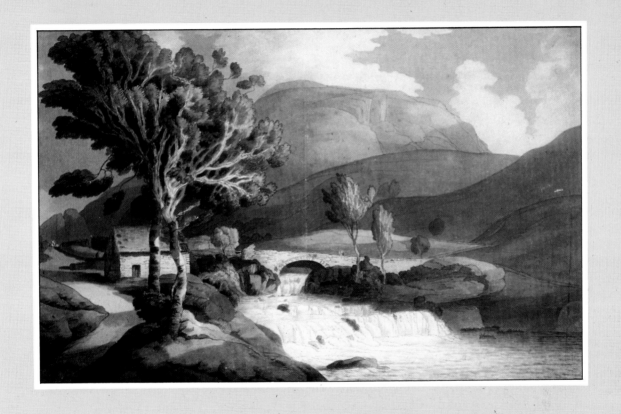

Paul Sandby—*'Haymaking at Dolwyddelan below Moel Siabod'* c.1790—
Fitzwilliam Museum, Cambridge

Sandb ured North Wales at least twice in the 1770's. He came first in 1771 with Sir
Watkin Wynn on a tour which included Llanrwst, fairly nearby, but not Dolwyddelan.
A second tour was made by Sandby in 1773 which may well have included a trip up the
delightful valley of the Lledr to Dolwyddelan. This watercolour thus probably stems
from sketches made on the 1773 tour. If it does come from that time, it was not until
much later, in the 1790's, that it was worked up into this picture.
The centre of interest is the church surrounded by trees. It is a low barn-like building
typical of the old churches of Snowdonia. To the left there is a farm house with a barn.
Moel Siabod dominates the background above the church. In the foreground in the hay
meadow there are on the left a young man chasing a girl and on the right women
haymaking wearing typical old-fashioned Welsh hats. Sandby often took trouble to
make the human figures in his drawings interesting and he has done so here. Under-
lying this drawing is the idea of Wales as a pastoral idyll.

*There are a good many more buildings in Dolwyddelan now than there appear to
have been in Sandby's time. The old church remains and the churchyard still has its
trees. Though houses block the view which Sandby had, sketching from near the
bridge over the Lledr with his back to the river, there is a pleasant open pasture on
the opposite side of the road to the church. (MR 736523)*

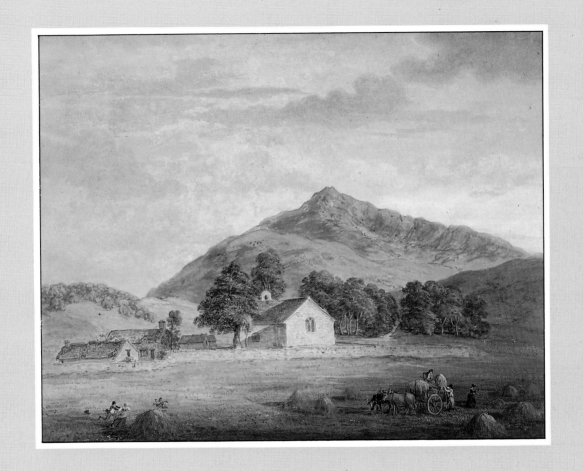

John 'Warwick' Smith—*'View from Snowdon'* c.1795—The National Museum of Wales, Cardiff

Smith, called 'Warwick' not because he came from that town, but because he enjoyed the patronage of the Earl of Warwick, made a tour of Wales in 1792. This view from the top of Snowdon dates from three years later. It is one of a pair, of which the other is a view from the head of the Snowdon Ranger path looking towards Anglesey. In it the Menai Straits are clearly visible and the whole coastline of the island including Holyhead mountain. Closer to, there is visible the top of Clogwyn Du'r Arddu and Moel Eilio.

This drawing, looking in the opposite direction, is taken from Bwlch Glas, and looks over Llyn Glaslyn and Llyn Llydaw. The topography does not seem to be entirely accurate: if the mountain in the background is Lliwedd it is out of its proper relation to Llyn Llydaw, while if it is Moel Siabod it is not sufficiently distant. However to have made at that time a record of the view from the summit of Snowdon was an achievement and the view is spectacular. The three figures and the dog nicely convey the feel of an adventurous eighteenth century mountaineering party seizing its opportunity on a clear sunny day.

Bwlch Glas lies between Crib y Ddysgl and the summit of Snowdon. (MR 608548)

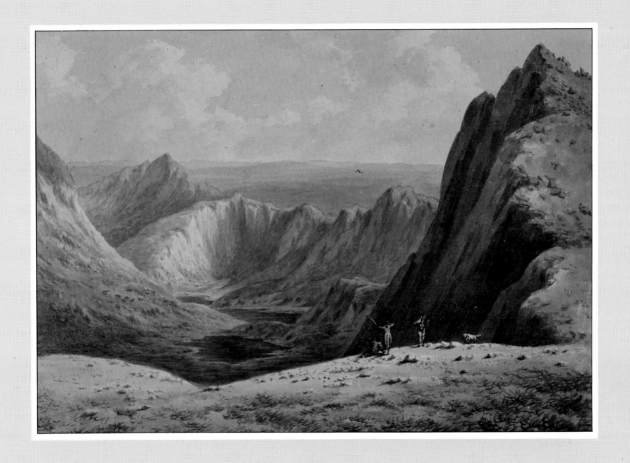

Thomas Girtin—*'Near Beddgelert'* c.1798—The British Museum, London

Girtin was born in the same year as Turner, 1775. He grew up in London and began work as a topographical draughtsman as also did Turner. Both artists worked for Dr.Thomas Monro, the principal physician of the Bethlem Hospital, who was himself an amateur artist and who employed and encouraged a number of young artists. Girtin and Turner both travelled to North Wales in 1798; Turner returned the next year and Girtin probably in 1800. That was only two years before Girtin's untimely death, while Turner had many years of work and fame ahead of him. Just how Girtin and Turner influenced each other is not clear, but it seems that Turner had a great respect for Girtin and reckoned him the greater. Girtin made this watercolour of the pleasant valley of the Afon Glaslyn above Beddgelert on his first visit in 1798. Turner made a very similar one in the same valley the next year. Girtin shows a new boldness and freedom and a new emotional expressiveness in his treatment of watercolour, going well beyond the tinted drawings typical of landscapists before him and of his own earlier years.

Girtin has used the freedom common to 18th century artists in depicting this landscape, so that the little hillock on which Dinas Emrys stands has disappeared and certain other features are moved. But the main lineaments of the scene are clear enough, and can be well seen by travelling some ¼ mile from the centre of the village of Beddgelert along the A498 towards Nant Gwynant, and then proceeding across the bridge over the Afon Glaslyn and about 150 yards along the by-road up a slight incline. (MR 594484)

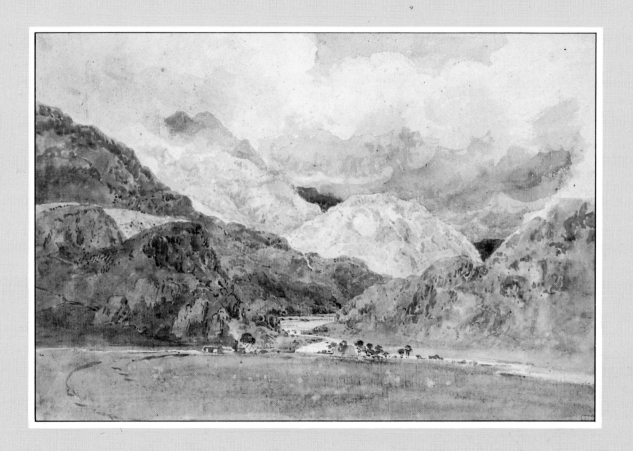

Joseph Mallord William Turner—*'Dolbadarn Castle'* c.1798-9—The Turner Collection, Tate Gallery, London

Turner made his first tour in Wales in 1792, and he revisited the country four times in the next eight years. His first visit to North Wales was in 1798, when he was still only 23. What he saw and drew on these tours was formative for him. A new range of subjects, particularly the mountains, evoked new responses and new styles of working. Though this is no more than a colour study it shows considerable inventiveness on Turner's part. He has experimented with his colour in such a way as to reveal the brush marks on the rocks beneath the castle and the ground below and his stopping out technique has produced a dramatic sky which merges into the mountains. Turner's concern here for atmosphere, weather and light is obvious, and is the making of the picture—it was a concern which was to remain dominant throughout his life. Turner has reacted to a scene already much painted with a work in which the turbulence of the atmosphere against the unmoving solidity of the castle is all.

The view of Dolbadarn Castle and Snowdon, which has been repeatedly painted, is not helped at the present time by a recently constructed car park and Llanberis sewage works. However one may find vantage points from which these are not too obtrusive, and there are very pleasing views across Llyn Padarn to Dolbadarn Castle and Snowdon from the Llyn Padarn Country Park. (MR 584606)

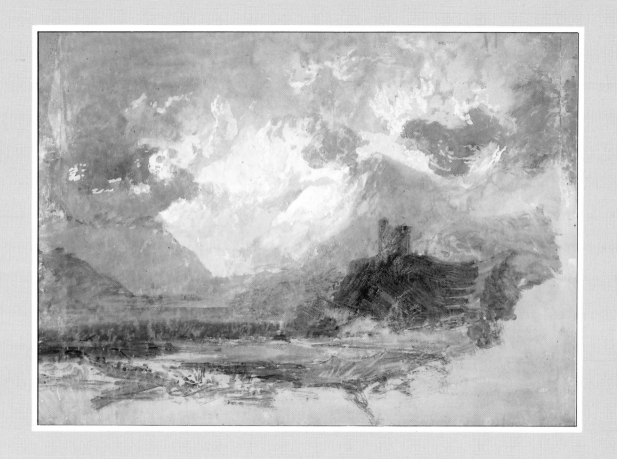

Joseph Mallord William Turner—*'Llanberis Lake and Dolbadarn Castle'*
c.1799-1800—The Turner Collection, Tate Gallery, London

This view of Dolbadarn Castle across Llyn Padarn comes from Turner's second tour of North Wales in 1799. It is one of a numbered series of watercolour studies which were not intended for exhibition but to which Turner nonetheless attached considerable importance. It forms a considerable contrast with the previous watercolour. Where all was cloudy turbulence here all is unmoved calm. That contrast in its turn reflects the sharp changes of character of the mountain scene as the time of day and the weather alter. The castle too has shrunk to an interesting feature in the landscape, no longer its key. The view is now dominated by the mountains and the lake themselves. Turner has mastered another mood in the mountains.

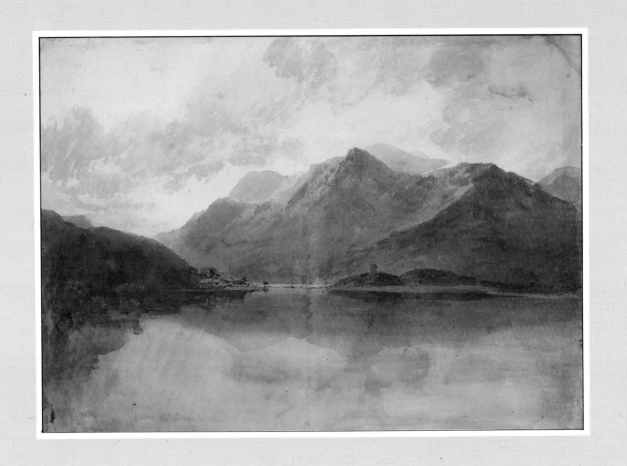

Joseph Mallord William Turner—'*Dolbadern Castle*' c.1799-1800—Royal
Academy of Arts, London

Yet another interpretation of the theme of Dolbadarn Castle, and the least near reality.
In it Turner has freely combined the castle, mountains and rocks, a waterfall, a rock
girt pool and some figures on a rock by its edge, so that as a whole the scene is not
recognisable. The castle itself is elevated and thrown into high relief by the light
behind it and clearly forms the dramatic and pictorial centre of the painting. When this
oil painting was exhibited at the Royal Academy in 1800, Turner provided some lines
of verse to accompany it, possibly of his own writing:

How awful is the silence of the waste
Where nature lifts her mountains to the sky.
Majestic solitude, behold the tower
Where hopeless OWEN long imprisoned, pin'd,
And wrung his hands for liberty, in vain.

Turner had a marked sympathy towards the historical associations of the subjects of
his works, and in this way he refers to the imprisonment of Owain Goch, the brother of
Llewelyn the Great, who was rash enough to challenge his brother's inheritance and
was incarcerated for twenty years until he was freed by Edward I's conquest of Wales.
The verse points up the mood of the painting, contrasting the pathos of the prisoner
long deprived of liberty with the magnificent, but quite unmoved, mountain peaks. It
was this painting that Turner presented to the Royal Academy as his Diploma work on
being elected an Academician in 1802, thereby acknowledging his debt to the Welsh
landscape in reaching this coveted honour.

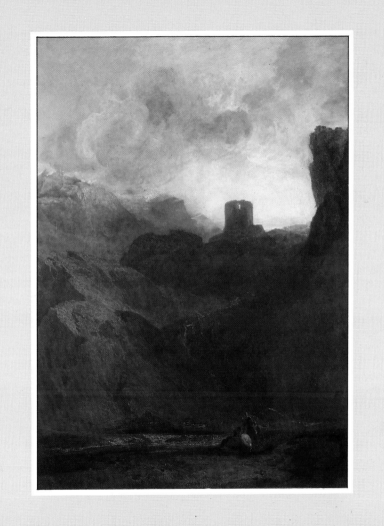

John Crome—'*Slate Quarries*' c.1804—Tate Gallery, London

The visitor to Snowdonia is apt to regard the slate quarries and slate tips as blots on an otherwise lovely landscape. Nevertheless quarries and mines have for many years been typical of the region; several artists have been drawn to them and found in them subjects for their work. The scale of the great terraces on which the quarrymen work or have worked is striking and there are in the quarries sheer cliffs dropping for hundreds of feet. This picture by the Norwich artist John Crome captures something of that scale, with the two diminutive figures in the foreground contrasting with the depth of the valley and the height of the mountains into which the slate quarries have been worked. Precisely where Crome painted this picture is uncertain, although it is known that he was in the slate quarrying region of North Wales in 1804. With sombre pallette he has painted a mountain scene strongly evocative of the landscape of Snowdonia.

There are two slate quarries open to the public in Blaenau Ffestiniog—Llechwedd and Gloddfa Ganol—where different aspects of the slate mining industry can be seen. There is also the North Wales Quarrying Museum in Llanberis together with the old workings in Llyn Padarn Country Park. The largest working slate quarry is in Bethesda.

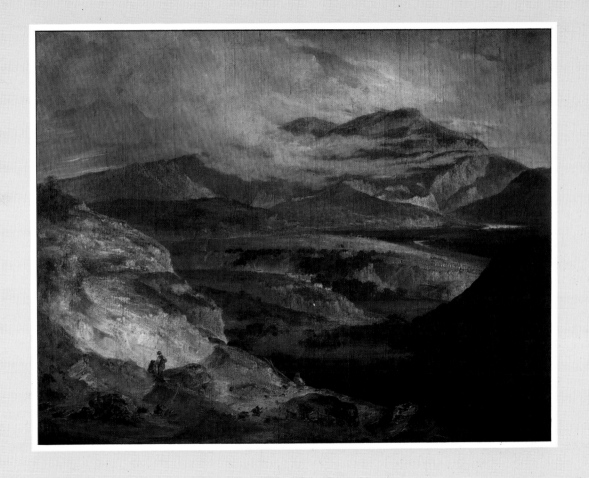

John Sell Cotman—*'Dolgelly'* c.1805—Fitzwilliam Museum, Cambridge

John Sell Cotman came from Norwich, and while he later came to have an affection for the gentler landscape of his native county, the hills and valleys of Wales seem to have awakened his artistic individuality. He sketched in Dolgellau in 1800, when he was only 18, and he was probably there again in 1802. The scenes he saw and drew must have made a deep impression on him, for he returned to them as subjects for his pictures for more than thirty years, even though he never revisited Wales.

This watercolour of Dolgellau will have been worked up in his studio from his sketches a few years after he made them. In keeping with the convention of his time Cotman has left the highlights of his picture—the river and parts of the sky—without any pigment. The contrasting colours of the river as it winds towards the sea and the varying tones of the mountainsides give a convincing sense of depth and distance. Cotman often liked to include arches in his pictures and the bridge in this one, though it is but a detail, has a pleasing series of such forms outlined against the river. Cotman has used his watercolour in a masterly way to portray the light of a typical British landscape under sunshine and cloud with the atmosphere cleared after rain.

This view of Dolgellau can be seen from the by-road from the Cross Foxes Hotel to Dolgellau about a quarter of a mile west of the lane to Groes-lwyd. (MR 743176)

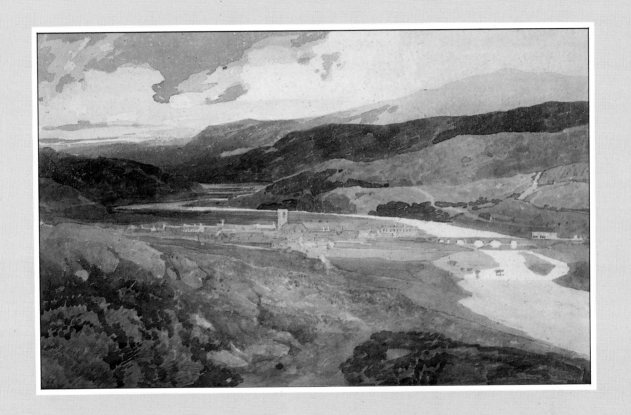

John Varley—*'Snowdon from Capel Curig'* c.1805-10—Victoria and Albert Museum, London

John Varley was born in Hackney, London, three years after Girtin and Turner. His natural inclination was to be an artist, but his father forbad it and he was apprenticed to a silversmith. However his father died when he was aged 13, and his mother allowed him to follow his bent. He was employed briefly by a portrait painter and then by an art teacher. In exchange for running errands and doing odd jobs he was allowed to join the other pupils and copy old master prints. Varley made his first visit to Wales in 1798 or 1799 with another landscape painter, George Arnald. He may have made a further visit in 1800, and he certainly did in 1802, with his brother Cornelius. John Varley was very much a master of watercolour—he hardly every worked in oils. He was instrumental in the founding of the Old Water Colour Society and exhibited with them regularly from 1805 until he died.

This view of Snowdon from Capel Curig had already become popular. Moses Griffith drew it to illustrate Pennant's *Journey to Snowdon*. So, following him, did Philippe Jacques de Loutherbourg and Richard Colt Hoare. The foreground and the middle ground have been treated by Varley with considerable freedom, and the height of the mountains has been accentuated. In spite of its unfinished state—the trees are incomplete, the figures are only sketched in and the lake has no colour—it is an attractive work with its broad flat washes of colour.

This is probably the most well known view of Snowdon, and can be seen from the Pinnacles at Capel Curig. From the field beside the church it is possible to walk up to the rocky outcrop. (MR 724582)

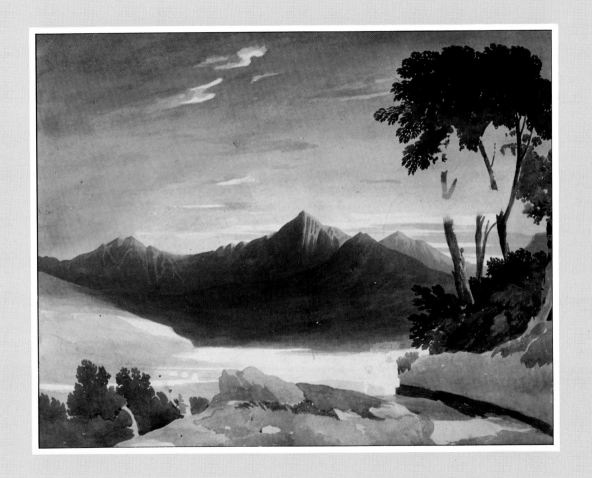

John Sell Cotman—*'Road to Capel Curig, North Wales'* c.1806—Victoria and Albert Museum, London.

Although the title ought to make the location clear, it is not immediately obvious where Cotman drew this scene. It cannot be on the road to Capel Curig from Betws y Coed, and it seems most likely that the view is of the Ogwen Falls, with Tryfan behind. On stylistic grounds the watercolour is to be dated some years after his Welsh travels and he was capable of allowing himself a good deal of licence in working up his sketches. The road from Bangor to Capel Curig does indeed pass this spot.

Cotman has drawn his mountain scene in the classic manner, with bold simple outlines and clearly defined masses. The bridge, of course, dominates the scene, with Cotman's favourite arches; the bridge parapet cuts straight across the picture. The dark mass of the mountain on the right contrasts with the light stonework of the bridge and the two horses beginning to cross it. The highlight of the lower part of the picture is the falls flowing away to the right, while the woman with her child provides a further human touch against the rocks on the left. The graduation of colours of the mountains in the background on the left gives a sense of depth and distance as in 'Dolgelly'.

From the bridge taking the A5 over the Afon Ogwen at the end of Llyn Ogwen, walk down the road for a few yards to scramble down the rocky bank by the Rhaeadr Ogwen. Looking upstream it is possible to see the remains of the old Packhorse Bridge beneath the arch of the present bridge. Tryfan dominates the scene behind. (MR 649605)

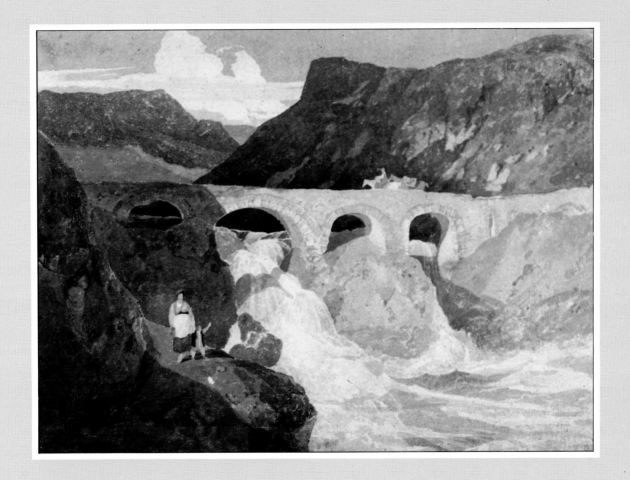

John Varley—*'Landscape with Harlech Castle and Snowdon in the background'* c.1815-20—Victoria and Albert Museum, London

Varley's last visit to Wales was in 1802 but he continued to make much use of his Welsh subjects for the rest of his life. At times he did so rather over repetitiously. Harlech Caslte was exhibited by him in 23 versions between 1803 and 1840. Varley used to tell his pupils that *Nature wants cooking,* and he was certainly not afraid to do the cooking himself. This 'Landscape with Harlech Castle and Snowdon in the background' has as its basis the magnificent panorama of Snowdonia from Morfa Harlech which is terminated by Harlech Castle on the right. Varely has used this basis on which to construct a pastoral scene in the tradition of Claude Lorraine with prominent trees, two of which neatly frame Snowdon itself, cattle, a stream and peasants. None of this has any basis in reality. But as Varley has drawn it it only serves to accentuate the grandeur of this North Wales scene.

The view of Snowdonia with Harlech Castle in the foreground can be seen from the sand dunes of Morfa Harlech almost at the extreme south end of the beach. (MR 574305)

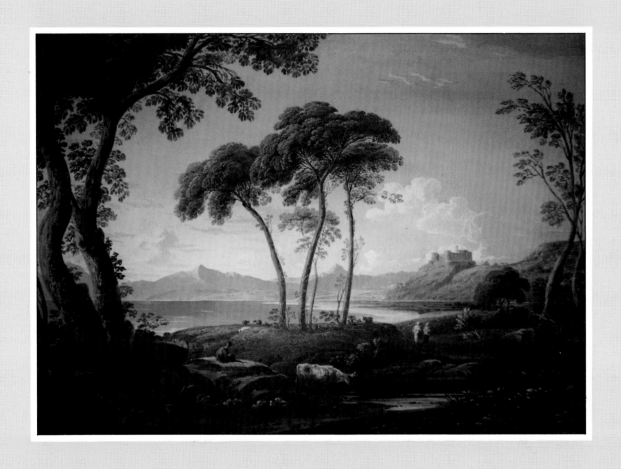

Anthony Vandyke Copley Fielding—'*Digging Peat at Traeth Mawr, on the Caernarvon and Merioneth border*' c.1820—The National Library of Wales, Aberystwyth

In the early years of the nineteenth century a great causeway was constructed across the Traeth Mawr by William Maddocks, a visionary planner and initiator of public works of improvement. After many adventures, seeming success followed by disaster, the causeway was completed about 1813. It meant that a large tract of fertile land, previously covered by the sea, was reclaimed for agricultural use. From the causeway there is a magnificent view looking northwards. There can be seen Moel Ddu and Moel Hebog, Snowdon, and to the east Cnicht, Moelwyn Mawr and Moelwyn Bach. It was not long after the reclamation of the Traeth Mawr that Fielding came to it to make his own picture of this view.

Fielding had had his first lessons in drawing from his father, who was also an artist. He first toured Wales in 1808 when he was 21. He then became a pupil of John Varley and one of the Monro circle. He made further tours in England and Wales. He taught drawing and was very popular as a drawing master. Ruskin praised him for his seascapes.

Fielding was more than a competent artist and this drawing of a particularly fine view is striking.

Fielding actually drew his view of Snowdon from the Traeth Mawr somewhat inland from Maddocks' causeway. The viewpoint appears to have been in Llanfrothen on the road to Prenteg opposite St.Catherine's Church. (MR 612417)

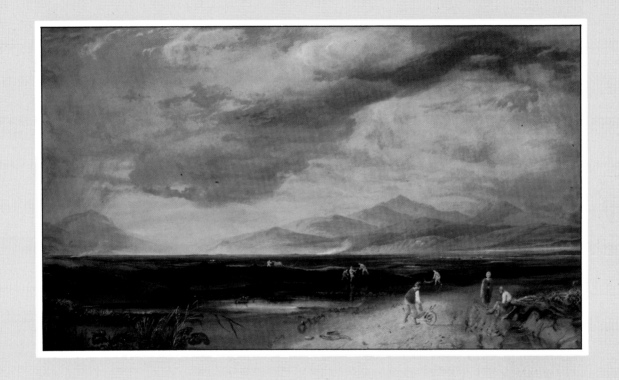

Joseph Mallord William Turner—'*Caernarvon Castle*' c.1833-4—The British Museum, London

Caernarfon Castle had been a very popular subject for artists visiting North Wales from the earliest days and Turner himself drew several versions of it. Many of these earlier renderings of Caernarfon Castle were formal and classical. Turner also treated the subject in this style. This watercolour is rather different. The mood of the castle on a dark day can be lowering or threatening, and its historical association with the subjugation of Wales by Edward I is also violent and threatening. In this picture, however, the castle is ethereal, floating in the glory of the golden evening sunset. This lightness of mood is strengthened by the women bathing in the warmth of a summer evening in the foreground of the picture, figures which take up so much of the interest of the composition. Though in some respects a development of the classical tradition there is a freedom in treatment of colour, light and atmosphere which is fresh. The effect is delightful.

This view of Caernarfon Castle from the bank of the Afon Seiont may be seen by starting at the Castle itself and walking along Saint Helen's Road, which leads to the properties on the waterfront, to a place where there is a gap and the quayside itself can be reached. Sailing vessels will most likely be in sight on the banks of the river, but it is less likely that anyone will be taking a plunge in its waters. (MR 482623)

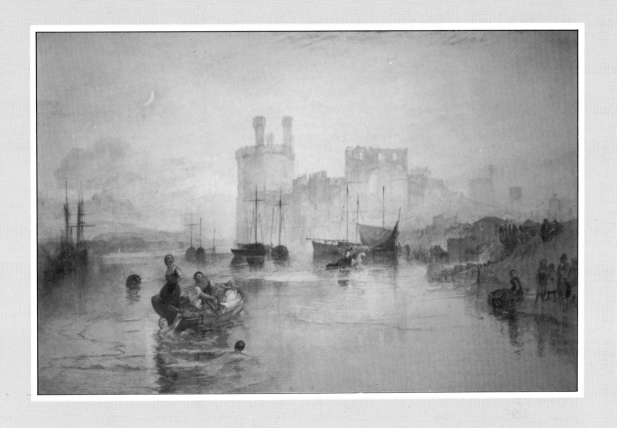

Joseph Mallord William Turner—'*Crickieth Castle*' c.1835-6—The British
Museum, London

This watercolour, together with the previous one of Caernarfon Castle, was part of a
long series of topographical works prepared by Turner for engraving under the title
Picturesque Views in England and Wales. Turner had not been in Wales for thirty years
and he must have drawn upon sketches made as a young man when he was there in
1798. In addition to his other talents he had an extraordinary visual memory. A few
lines sketched in a notebook were enough to recall a scene fully. Cricieth Castle was
not in origin one of Edward I's constructions, although he made use of it. It was older,
like Dolbadarn Castle, a fortification of one of Wales' native princes. However Turner
does not draw on this historical association to humanise his picture, but instead shows
an incident on the foreshore. A ship has been wrecked in a storm at sea (a favourite
theme for Turner, drawing on his own experience as a traveller), and customs officers
are inspecting the goods which have been salvaged. The incident only accentuates the
castle's sea girt position and its stability in the face of all the assaults of the storm and
the sea.

*Cricieth Castle stands out well when seen from the beach on the eastern side of
Cricieth. (MR 507380)*

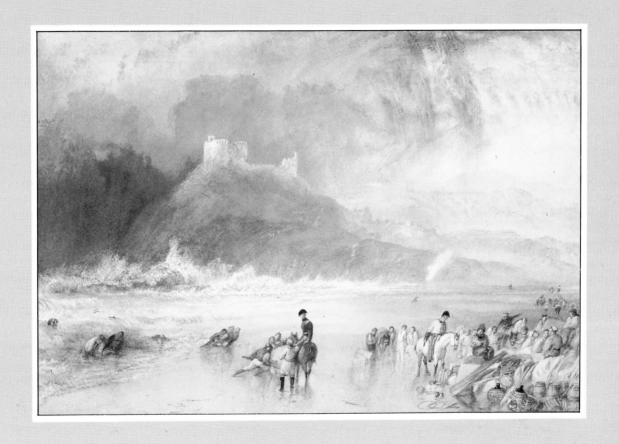

Samuel Palmer—'*The Waterfalls, Pistyll Mawddach*' c.1835-6—Tate Gallery, London

Samuel Palmer was a visionary painter and a man of deep religious faith. As a young man he, with a group of like minded friends, spent much time in the company of William Blake, himself another visionary painter and a great poet. Palmer was deeply influenced by him. Palmer's greatest paintings were made in response to the English countryside in the Darenth valley in Kent. This painting of the Pistyll Mawddach deserves to rank with them. Of it Samuel Palmer's son said that it contained his father's whole heart.

There are two waterfalls in close proximity where the Afon Mawddach is joined by the Afon Gain—Pistyll Mawddach, more generally known as Rhaeadr Mawddach, and Pistyll Cain. They are a few miles north of Dolgellau, and to reach them leave the A470 to Trawsfynydd turning east at the northern delimit signs for Ganllwyd over the Afon Eden and keeping right until a carpark is shortly reached. From the car park follow the track over the Mawddach and for about two miles along its left bank on the so called Gold Road. Leave this track turning left into the valley when a small stone bridge over the Mawddach comes into view. Cross the bridge and turn left downstream. Both waterfalls can be well seen. (MR 735275) It is possible to walk back to the car park on the right bank of the Afon Mawddach.

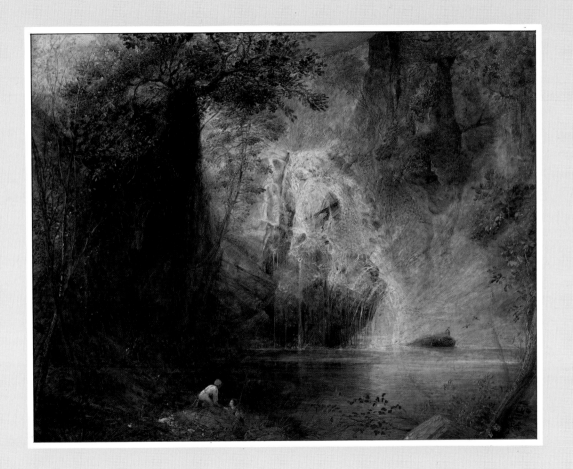

David Cox—*'Pont y Pair'* c.1836—Fitzwilliam Museum, Cambridge

Cox took lessons with John Varley, an established watercolourist, and himself began both to draw and to teach. In 1805 Cox made his first visit to Wales which was to be the first of very many. In later life he made annual journeys to Betws y Coed, where he stayed at the Royal Oak Hotel. A large bedroom was always reserved for him there and on wet days he would spread out his work to dry on the spare bed. An inn sign for the Royal Oak showing the oak tree concealing Charles II and the Parliamentarian soldiers searching for him was painted by Cox and is still preserved in the hotel. Cox was popular in the village and children would vie with each other for the privilege of carrying his equipment. Resulting from his trips to Wales is a magnificent body of watercolours of the village of Betws y Coed, its surroundings and the mountains of Snowdonia. This picture was made from the bank of the Afon Llugwy opposite the Royal Oak Hotel, looking upstream 200 yards to Pont y Pair. By the riverside there are now trees obscuring the openness of the view, and one must now look upstream from the bridge for a broader view of the river. Cox loved Wales—a letter written in 1846 refers to 'another visit to dear Wales'—but he would have hated Betws y Coed as it is today. Though he supported a Liberal in his younger days at Hereford, he was at heart a Tory—of his age, of course—who believed in the social orders. He drew the peasantry securely in their place, as in this picture. It is possible that he depicted Betws y Coed as more rural than it actually was, but the contrast nonetheless is striking.

The Royal Oak Hotel is on the A5 as it runs through Betws y Coed, near the church. (MR 793566)

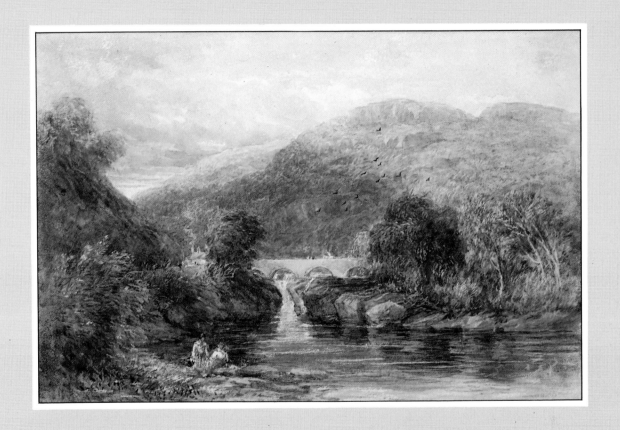

David Cox—*'Rhaiadr Cwm'* c.1836—The British Museum, London

Like Turner's 'Caernarvon Castle' and 'Crickieth Castle', Cox's 'Pont y Pair' and 'Rhaiadr Cwm' were prepared for engraving. The book to be illustrated was Thomas Roscoe's *Wanderings and Excursions in North Wales*. Cox prepared about half the drawings. It was so successful that a companion volume for South Wales was published the following year, and Cox contributed to that also.

In his *Modern Painters* John Ruskin wrote: *. . . with equal gratitude I look to the drawings of David Cox, which in spite of their loose and seemingly careless execution, are not less serious in their meaning, nor less important in their truth. . . The recollection of this will keep us from being offended with the loose and blotted handling of David Cox. There is no other means by which his object could be attained; the looseness, coolness and moisture of his herbage, the rustling crumpled freshness of his broad leaved weeds, the play of pleasant light across his deep heathered moor or plashing sand, the melting of fragments of white mist into the dropping blue above; all this has not fully been recorded except by him.* It is a deserved tribute to one who loved the countryside; this water-colour is a fitting example of his love and skill.

Rhaeadr y Cwm lies close to the B4391 from Ffestiniog to Bala, about two miles east of Ffestiniog. There is a car park and at a short distance a viewpoint. (MR 737418)

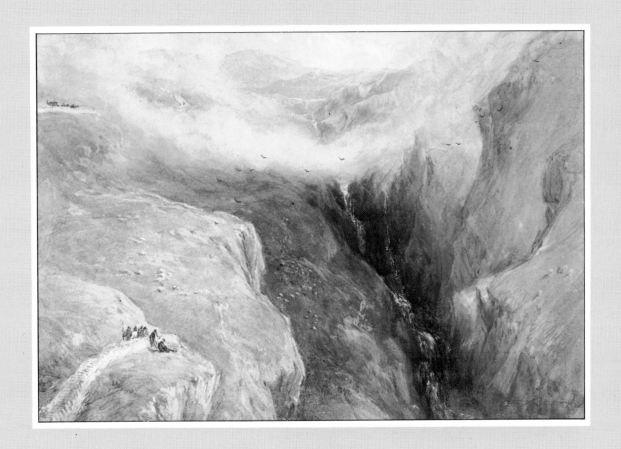

Ebenezer Newman Downard—*'A Mountain Path at Capel Curig'* c.1860—
Tate Gallery, London

Downard specialised in landscape and scenes of everyday life, like this painting at
Capel Curig. He was influenced by the Pre-Raphaelite Movement, and especially by the
example of W.Holman Hunt. One of the Pre-Raphaelites' guiding rules was to study
directly from nature, often carried out with great attention to detail. That is reflected
here in the care with which rocks, flowers, trees and sheep are painted. The Pre-
Raphaelites also tended to use bright colour, at times verging on the lurid. Downard
has used bright colours—violet for the rocks of the mountain, purple for the foxgloves,
vivid green for the vegetation on the rocks and orange for the exposed soil of the path;
yet they are not colours strange to nature and the colour of the path, for instance, may
reflect an iron rich soil. Then the Pre-Raphaelites often chose subjects with a very
direct appeal (compare, for example, Ford Madox Brown's 'Pretty Baa Lambs'). This
picture shares something of that appeal with the simple but pretty farm girl followed
by a lamb. It does too faithfully represent the countryside near Capel Curig and is a
work of considerable charm.

*There is scenery like this looking east on the little knoll above Plas y Brenin about half
a mile west of Capel Curig (MR 716579).*

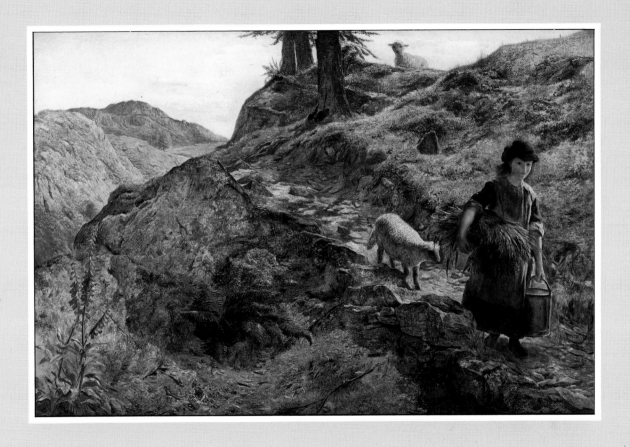

Walter Crane—*'Llyn Elsie near Bettws y Coed'* c.1871—Victoria and Albert Museum, London

Crane was best known as a book illustrator, especially of children's books, in which work he preceded Kate Greenaway and Randolph Caldecote. He was in fact a very versatile artist and designer with a wide range of achievement. This included landscapes which at one period were very important to him. Crane's best work was decorative and imaginative and something of that flavour is found in this picture, particularly in his treatment of the animals and the rocks in the foreground. Crane had always been fond of animals and from boyhood liked to draw them. As an apprentice he got a student season ticket to the London Zoo. He accumulated sheaves of animal sketches which he used later on as an illustrator. His passionate love for animals extended to having them in his home—a jerboa, a golden pheasant, an alligator, a marmoset, an owl, a rabbit, guinea pigs, cats and dogs. He would work with a squirrel perched on his shoulder. His fondness for animals is revealed in this picture in the cattle and the wading birds (perhaps godwits), which enliven the environment of Llyn Elsi.

Llyn Elsi is still a rather wild and deserted spot, the major change being the afforestation. This watercolour was made on the south east bank of the lake looking over it towards the mountains of the Carneddau range. It can be reached by proceeding slightly more than a quarter of a mile up the A5 from Pont y Pair in Betws y Coed, and then taking a path to the left uphill to Hafod-las. From there the path continues upwards to Llyn Elsi. It is possible to walk round the lake to the south end by the east side. (MR 783551)

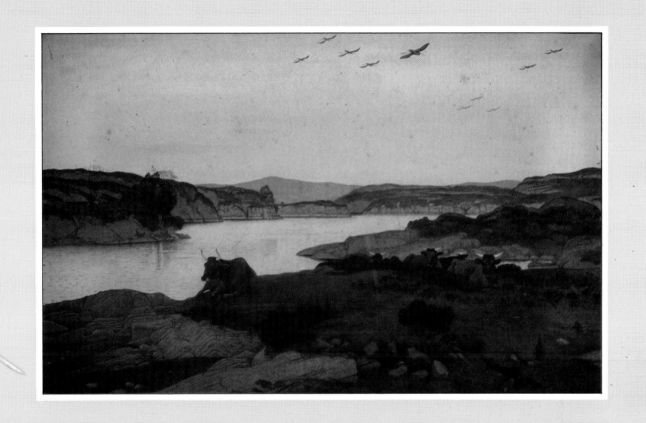

James William Walker—*'The Old Road to Bangor, Capel Curig'* c.1880—
Norfolk Museums Service (Norwich Castle Museum)

Walker·was a minor member of the Norwich School of artists, of which the great
names were John Crome the elder and John Sell Cotman. Walker trained at the
Norwich School of Design. The Norwich painters had a special affection for the
landscape of the countryside, not least of Norfolk, though other parts of Britain also
interested them. Walker eventually settled in Southport and from there made excur-
sions for drawing around the North Country, including the Lake District, to North and
South Wales, and to Norfolk, among other places.
This drawing, of the 'Old Road to Bangor, Capel Curig', is easily identifiable with the
mass of Gallt yr Ogof dominating the scene and Pen yr Ole Wen on the right. On the
left the summit of Snowdon just appears over the flank of Gallt yr Ogof, but this is
imaginary and Walker must have included it to locate the scene. Walker has drawn the
mountains with a spring mantle of snow and caught the clear light that sunshine on
snow brings. His pleasure in things rural is shown by the care with which the grassy
track on the mountainside, the Old Road, is represented.

*From the Post Office in Capel Curig take the track leading over the river Llugwy and
on up the right bank past Gelli. Walker's scene comes into view after about half a
mile. (MR 717589)*

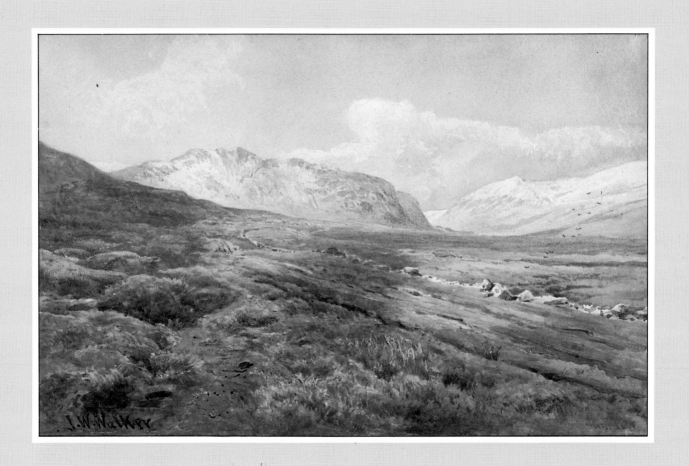

James Dickson Innes—*'Arenig'* c.1910—The National Museum of Wales, Cardiff

It cannot be common for an artist to enter into an intense emotional relationship with a mountain, but J.D.Innes certainly did with Arenig. Innes was a Welshman, born in Llanelli in 1887. He first visited North Wales to paint in 1910. Innes had by this time been diagnosed as suffering from tuberculosis, but it did not stop him travelling rough. It was late in 1910 that Innes arrived one night at an isolated inn at Rhyd-y-Fen. The next morning he saw Arenig Fawr rising above him, and was captivated by it.
In the early spring of 1911 he returned to Arenig. By this time Innes had formed a friendship with Augustus John. Innes preceded John to Arenig and when John arrived Innes met him. John later wrote: *Our meeting at Arenig was cordial, and yet I seemed to detect a certain reserve on his part; he was experiencing, I fancy, the scruples of a lover on introducing a friend to his best girl—in this case the mountain before us which he regarded, with good reason, as his spiritual property.* The two artists rented a cottage at Nant Ddu, a mile or so to the west, and worked from there. Innes' activity, John said, was prodigious; he rarely returned after a day's work without having completed two paintings. He would walk for long distances over the moors to find the right view and the right light.
John wrote of Innes: *His passionate love of Wales was the supreme mainspring of his art and though he worked much in the South of France Mynydd Arenig remained his sacred mountain and the slopes of Migneint his spiritual home.*

Arenig Fawr lies near the A4212 from Bala to Trawsfynydd and is close to Llyn Tryweryn. There is a good view of it from that road half a mile to the east of the lake. (MR 797384)

Augustus Edwin John—*'Llyn Tryweryn'* c.1912—Tate Gallery, London

John was a native of Wales; he was born and brought up in Tenby. He trained as an artist at the Slade School in London, where he was acclaimed as a brilliant student. After the Slade he led a somewhat rootless and restless existence in spite of marriage and the birth of six sons, to his wife Ida and to Dorelia, who effectively became his wife when Ida died after the birth of his youngest boy. In 1910 his travels took John to Provence which greatly attracted him. He had made his name with figure compositions but Provence led him on to landscape. It was the next year that James Dickson Innes, whom he had first met when Innes was a student at the Slade, persuaded John to join him in North Wales. Innes had already become deeply attached to the countryside around Arenig, and John was to be impressed too. *This is the most wonderful place I've seen*, he wrote to Dorelia, . . . *the air is superb and the mountains wonderful*. The two artists worked very productively throughout the summer. They rented a cottage at Nant Ddu which became one of John's many bases over the next years until Innes became too ill to paint any more.

Some of John's finest works were painted at Nant Ddu. There are some lovely portraits in a mountain setting (e.g. The Red Feather, The Orange Apron). He also painted a number of pure landscapes including this one of Llyn Tryweryn, about a mile from the cottage. In the distance can be seen the summit of Rhinog Fawr.

Llyn Tryweryn lies on the A4212 five miles east of Trawsfynydd (MR 789386)

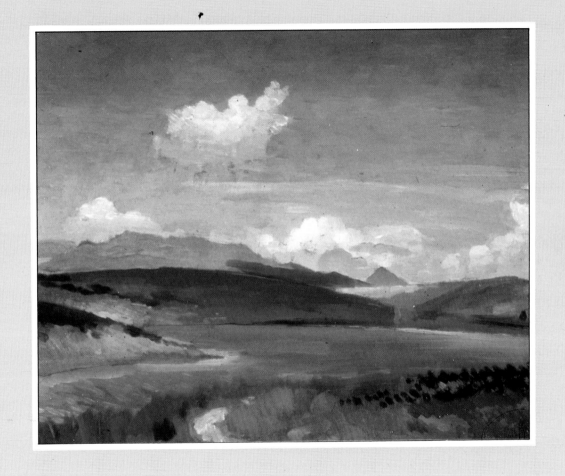

Stanley Spencer—*'Snowdon from Llanfrothen'* c.1938—The National Museum of Wales, Cardiff

Stanley Spencer was an original genius as a painter and many of his works were of great power, particularly those on religious themes. But he was also decidedly eccentric. From choice he lived a very Spartan existence and never took a holiday. Short in stature, he could be seen pushing a pram around carrying his painting materials and is said to have taken it with him when he visited Wales. He married his first wife Hilda in 1925. About five years later he conceived the scheme of compiling a vast autobiography, which actually took the form of love letters to his wife. Their divorce in 1936 made no difference to the flow, nor did her death in 1950. Everything went in— imaginings, fantasies, confessions, musing on the divine, philosophical speculations, erotica (and he was at times obsessed with sexuality), opinions on people, music, art— nothing was too trivial. Yet for all his oddness he was good company—he loved people, he loved talking, he had a sense of humour, he was valued by his friends, and he had very few enemies.

This landscape was painted in September 1938. His first wife, Hilda, had gone on holiday with her mother to stay at a house near Snowdon, and though by then divorced, Spencer went to stay with them. Landscapes were his staple. He could produce excellent works very rapidly, one every week or ten days. They were popular and sold well. But he came to loathe them. In later life he was sitting one day in a room with a view of unspoilt country. He asked: *Please may I turn my back to the window? Landscape still makes me feel quite ill.* In this picture the heights of Snowdon are kept very much at a distance in order to emphasize the lushness of Llanfrothen.

This view is taken from the by-road that leads from Garreg, Llanfrothen to Croesor, leaving Plas Brondanw on the left and proceeding past a very small cemetery on the right before reaching the head of the footpath on the left at Tan-lan (MR 619427).

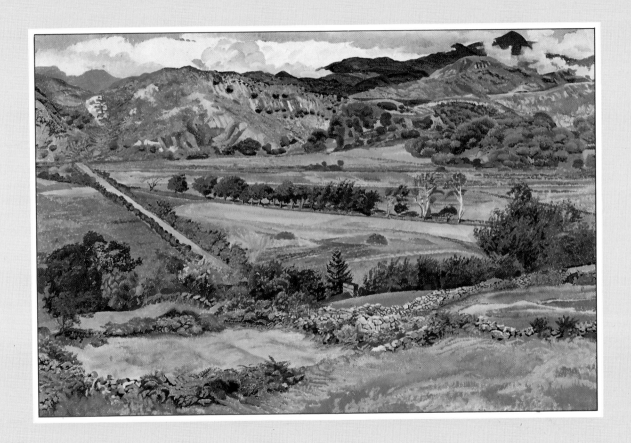

John Piper—*'Roman Amphitheatre of Tomen y Mur, near Ffestiniog'* c.1943—
Birmingham City Council Museum and Art Gallery

Piper's work as a war artist took him to Wales in 1943 and it evoked this dramatic landscape. It is of the Roman amphitheatre at Tomen y Mur, near Ffestiniog. Though it is not a mountain top, Tomen y Mur is an airy spot commanding views of the landscape in several directions. The remains of the amphitheatre, a low oval embankment some 4' high, can be seen with a farm building behind and a mediaeval motte on the site of the main Roman camp. In the distance all is threatening cloud. The subject appealed to Piper with its Roman and mediaeval historical connections, and the picture obviously stands itself in the romantic tradition, so that Piper, along with Graham Sutherland, Paul Nash, Henry Moore and others have been dubbed Neo-Romantics. Piper defined his mood and understanding in North Wales from the earliest landscapes he drew there.

The amphitheatre of Tomen y Mur is reached by proceeding south for a quarter of a mile from the junction of the A470 and the A487 two miles south of Ffestiniog, then turning left under the railway bridge and up the side road until a cattle grid is reached. The remains of the small amphitheatre are immediately forward on the right. A fine view is gained from the mound of Tomen y Mur 300 yards to the south west. (MR 708389)

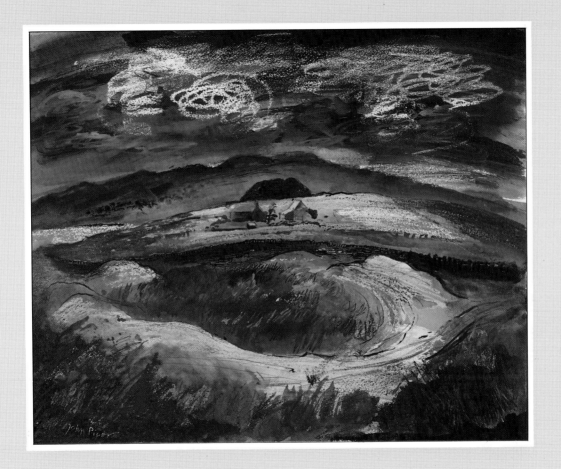

Kenneth Rowntree—'*School at Upper Corris with Cader Idris, Merioneth*' c.1948—The National Library of Wales, Aberystwyth

In 1939 the young publishing house of Penguin Books began to publish a special series entitled *King Penguins*, books with a short text and numerous colour plates. They were hardbacked rather than paperbacked and they were produced and illustrated with great care for their appearance. They rightly received acclaim. Among the series was one entitled *A Prospect of Wales*, a collection of watercolours by Kenneth Rowntree, with an essay by Gwyn Jones. Rowntree had been in Wales to draw before and it seems that the landscape of Wales attracted him. This picture, of the school at Upper Corris, with Cadair Idris in the background, is one of that collection. In it Rowntree combines strong forms (the school itself, the mountains and the pleasingly obtrusive slate fence) with subtle colouring—a range of greys relieved by such details as the lichens on the slates and the grasses in the meadow.

Upper Corris School is now a mountain centre. The building has lost much of its Victorian decoration, but is essentially the same, and even the slate fence remains. It stands on the A487 from Dolgellau to Machynlleth in the village of Corris Uchaf. (MR 739092)

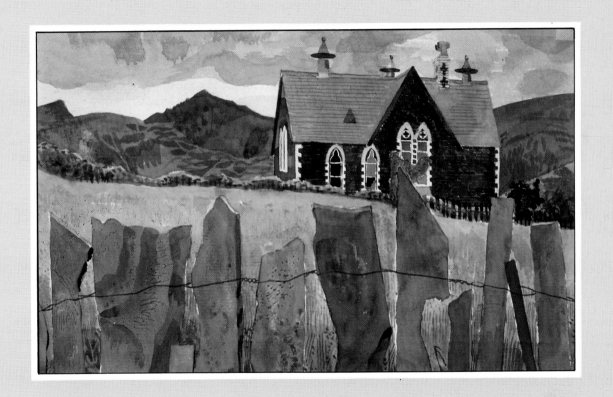

John Piper—*'Ffynnon Llugwy'* c.1949—The British Council

Piper continued to visit Snowdonia after the war and he rented a cottage in Nant Ffrancon in 1949 and subsequent years. Though Piper is not a native of Wales his wife Myfanwy Evans is Welsh and so many have been their sojourns in Wales that he has come to be counted an honorary Welshman. Piper's visits were often made in winter. While he was in Wales Piper drew a long series of landscapes of the mountains of Snowdonia. Unlike many studies of the mountains they are unrelieved by human figures. That does not mean that Piper regards the interaction between the landscape and the beholder as a matter of indifference. Far from it. Piper records in a private note his sensations when he was near the summit of the Glyders: *Mist blowing across all day: visibility about 15-20 yards only; curious sensation in presence of gigantic boulders, giant coffin slabs, pale trunk-shaped rocks, disappearing into grey invisibility even at close range. The affectionate nature of the mountain not changed by the acute loneliness and closed-in feeling induced by the mist; but an atmosphere of an affectionate cemetery.*

Piper is well aware of the tradition of the sublime, that which exalts, but yet may arouse anxiety or fear. His own pictures are sombre, yet the scale of their subjects is such as to exalt. In him the tradition of landscape painting in Britain is renewed and developed evoking a new response to the desolate yet grandiose scenery of the mountains of Snowdonia.

Ffynnon Llugwy lies on the north side of the Ogwen Valley underneath Carnedd Llywelyn. It can be reached by following the mountain road which begins at the A5 a few hundred yards from Helyg. (MR 694625)

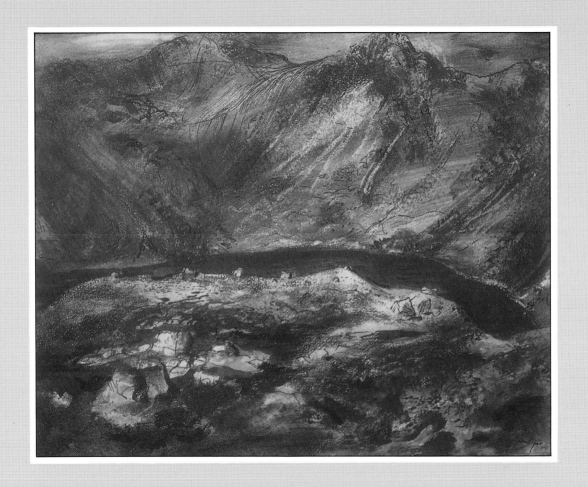

Kyffin Williams—'*Snowdon from Tŷ Obri*' c.1980—The National Library of Wales, Aberystwyth

Kyffin Williams is a Welshman, a native of North Wales, and lives and works at Llanfairpwllgwyngyll in Anglesey. Williams has an obvious affinity for the wilder parts of North Wales and has painted them in their more sombre aspects. He has written: *So many English artists dash towards the Mediterranean as soon as the sun begins to shine in summer. This yearly migration has always baffled me since I am sure a painter can paint his own land better than anywhere else. I have been extraordinarily lucky to have been born and reared in such a lovely landscape among people with whom I have so great an affinity. This world and its faces I have painted for nearly thirty years and I can really see no point in doing anything else.*

In this painting the broad prospect of the snowcapped peaks of the Snowdon massif in the bright sunshine is full of grandeur. If the pastoral countryside appears benign it is certainly not that Williams is unaware of the hardness which Welsh farmers have to face in their lives. But here the farmers are clearly at ease with the land.

From Porthmadog leave the A487 road to Penrhyndeudraeth on the left about half a mile beyond Minffordd. Proceed under a narrow bridge carrying the Festiniog Railway. Take the next turn to the right (cul de sac) and proceed until Tŷ Obry is reached at a sharp turn to the left. The viewpoint will have been from the road leading to the farm. (MR 604395)

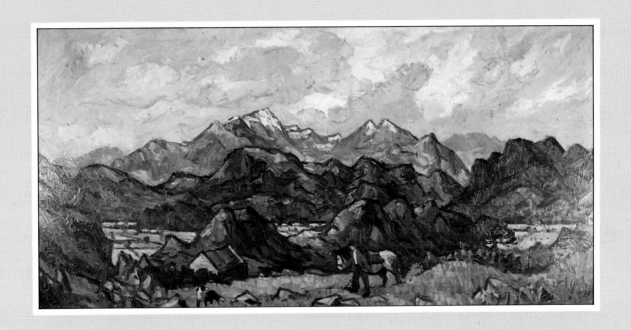

Other Welsh art books
published by Y Lolfa:

SNOWDONIA—MYTH AND IMAGE
Anthony Griffiths
A photographic study of 32 places in Snowdonia.
Complementing each striking image is a concise text dealing
with historical and archaeological facts and curiosities, with
an emphasis on Welsh legend and folklore.
0 86243 276 6
£5.95

CYMRU'R CYNFAS/*WALES ON CANVAS*
Hywel Harries
This handsome book has become the standard introduction
to pictorial Welsh art today and shows the work of fifteen
contemporary Welsh or Welsh-based artists. A feast of
photographs, many in colour, accompany the text, much of
which is in the words of the artists themselves. An ideal gift;
new bilingual edition with additional photographs now
published.
0 86243 054 2
£8.50 hardback

DELWAU DUON/*SYMPHONIES IN BLACK*
Nicholas Evans and Rhoda Evans
Nicholas Evans is unique for many reasons. He became
overnight an idol of the British establishment but had only
started painting when he was 70 years old. His heroic, darkly
dramatic paintings are about the early days of coal-mining in
Wales and in this collection, his daughter shows her own
talent by vividly relating the historical background to her
father's paintings. Bilingual.
0 86243 135 2
£9.95 hardback

IMAGES OF WALES
Ron Davies
A collection of full colour photographs by a professional
photographer from Aberaeron, Cardiganshire. Whether in the
small cameo or wider landscape, he invariably captures the
unique, timeless atmosphere of Welsh Wales. In small
hardback format, a book to be treasured equally by tourists
and Welshmen.
0 86243 226 X
£3.95 hardback

THE SEVEN WONDERS OF WALES
Photograhy by Ron Davies
Text by Elin Llwyd Morgan
In a variety of glorious full colour photographs, Ron Davies
has captured the atmosphere and beauty of the celebrated
Seven Wonders of Wales which have attracted and enchanted
visitors from over the border for two centuries. With each
Wonder is a concise text relating the background history.
0 86243 292 8
£2.95

Send now for your free copy
of our 80-page catalogue!

Talybont, Ceredigion SY24 5HE
phone (0970) 832304, fax 832782